Art in Junior Education

Prepared by a group of H M Inspectors of Schools

London
Her Majesty's Stationery Office

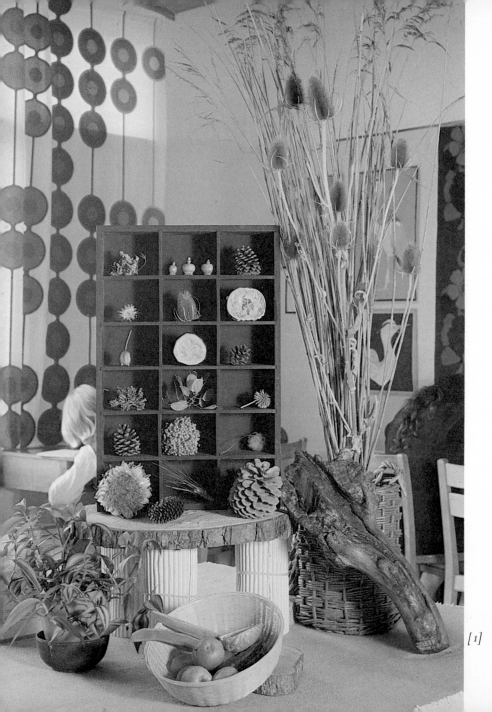

Contents

Introduction 3
Art education 3
School One 7
School Two 11
School Three 13
School Four 14
School Five 17
School Six 20
School Seven 22
School Eight 27
School Nine 31
Conclusions 35
Teachers and teaching 36
Preparation and planning 37
Reference materials and resources 40
The development of skills 42
Some discussion points for schools 48
Background reading 48

ISBN 0 11 270458 1

Introduction

Art education

What is art education, and what has art to offer to children? It can heighten their awareness of sensory experience and sharpen their powers of observation. As children perceive more acutely, they respond more deeply and with more understanding to the natural and man-made world. Form and order, pattern and design become clear to them, and they evolve their own images to record their responses and make something new. The practice of art – the stimulus of drawing, painting and making things – leads them also to a lifelong appreciation of works of art from different times and places and gives access to their meaning. The children come to realise that there are experiences for which words alone will not serve.

The purpose of this book is to describe some good practice in art education for pupils in the 8-11 age range, and to identify the elements contributing to its success. A group of Her Majesty's Inspectors of Schools, experienced in looking at primary schools and especially interested in art education, visited a number of schools, and talked with heads, teachers and children about their work. Here they describe what they saw and consider how the work was brought about.

There is general agreement that the visual arts are important for children. Many teachers assert that language development is accelerated by association with drawing, painting and making things. They also value the contribution made by an understanding of pattern and form to the learning of mathematics and science. Their views are confirmed by our observations. It is worth remembering that the 11-year olds in primary schools may enjoy only two or three more years of art education before having to make decisions which may severely reduce or even eliminate their formal education in the visual arts. As with the other expressive arts, the reemergence of these interests at a later stage as a life-enhancing

[2]

involvement depends heavily on the right experiences at this formative time in children's development.

During the course of the visits it became clear that, in those schools which offered an experience of

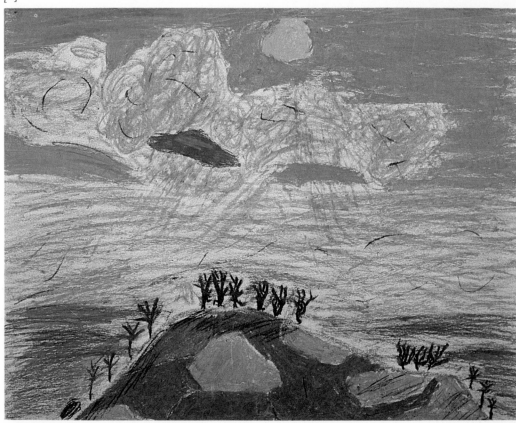

3

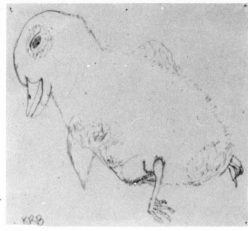

[3]

quality in this area of the curriculum, there was a consensus among the teachers about the way art education should be developed. It is not easy to put these developments in any order of priority because they fit in with or arise from one another. General progress in school depends so much on the teacher's observation of each child, as a basis for planning the stages of his learning. The most important result of this observation is the growth of a closer understanding between teacher and taught. The conviction that good work arises from first-hand experience and individual observation clearly contributes to general progress. Every kind of response to experience is revealing to the percipient teacher who can use his knowledge and understanding as a basis for the encouragement of a sensitive response to other people and to the environment. Within the environment the emphasis may be on the streets or countryside surrounding the school, or, more intimately, the classroom, arranged to encourage curiosity and sensitivity.

Progression in learning is dependent on the children's physical, mental and sensory development: this can be accelerated to some degree by the quality of the teaching and by the use the teacher makes of his knowledge and experience. Yet children must have time to absorb first-hand experiences. Drawing, and working with three-dimensional materials, provide valuable opportunities for contemplation and learning. Pupils become involved in the prolonged study of form and order, pattern and design, without which many other kinds of learning are unlikely to take place. There are many different reasons for looking and recording. They include various aspects of environmental studies and project work as well as a need for personal expression. There is something of the latter in any individual use of knowledge, feelingly communicated. The cloud study [2] with its parallels to sky studies by Constable and Turner, is evidence of the potential for an appreciation of works of art from different times and places. This appreciation should be part of the quality of life for everyone, and, as with other expressive arts, understanding begins in the primary school. The drawing of the dead chick [3] is an individually observed, charming but also moving expression of the feeling experienced by that child, perhaps face to face with death for the first time.

The teachers whose work is described believe that children must have help in organising their reactions to experience and in managing whatever medium is chosen to express or give form to that reaction. So they believe that skills must be taught at appropriate stages if children are to develop beyond their earlier spontaneous discoveries. The freshness and strength of the work of younger children [4] exhibit a confidence and delight in colours, shapes and textures which can be used to advance their later art education. The good teacher preserves the personal but increasingly complex imagery of the child while helping to promote better and more craftsmanlike ways of using the tools and materials chosen.

Descriptions follow of some of the work in nine of the considerable number of schools visited.

4

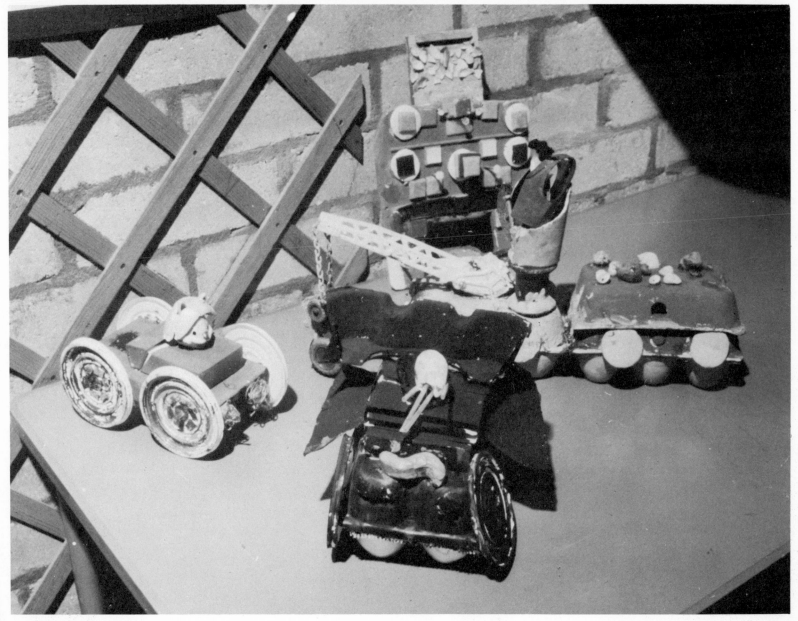

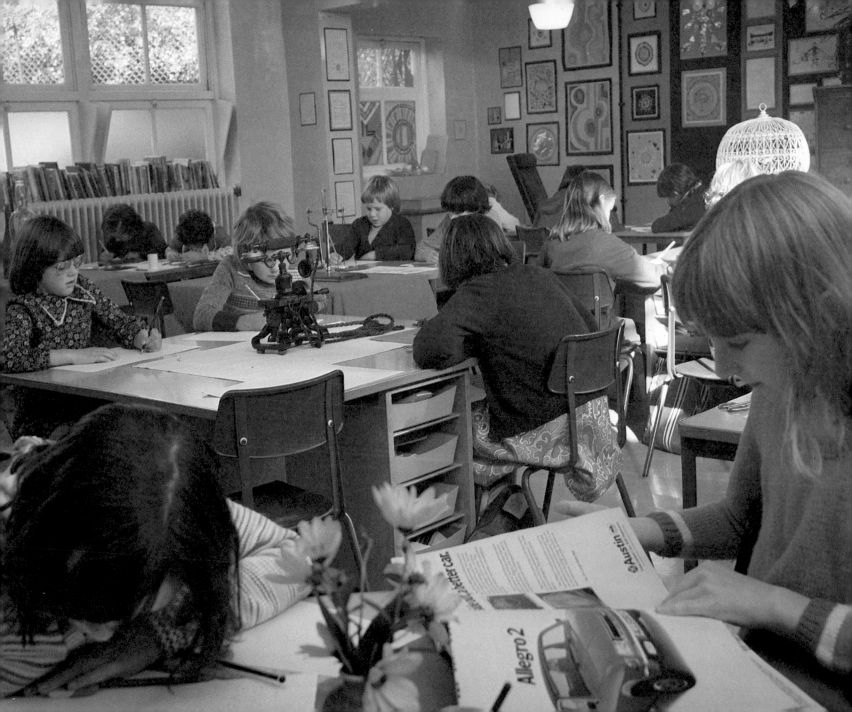

School One

Number on roll: 268
Age range: 5-11 years
Old urban community in a small industrial area.

The people who work here love colour. There is a striking contrast between the neutral surroundings outside –the grey stone walls of the old school and the grey tarmac playground – and the bright, but controlled, colours inside. The visitor is attracted to a waiting area where the predominant colour is yellow – the colour chosen to mount the children's paintings of sunflowers and white-petalled daisies which are exhibited there. A creature constructed of metal tubes sprayed with silver, whose horns are made from bicycle handlebars, confronts a cascading plant growing out of a nineteenth century chimney cowl with a fluted edge.

This school engages you visually; there is a wealth of discovered detail and enjoyed pattern; the well-mounted clusters of drawings and painted studies of objects that decorate the entrance passage demand closer inspection. The narrow passage suddenly opens into a large vaulted hall with a beautiful polished floor. A music area in the hall is a place attractive to children – violins have been hung on pegboards like works of art, and other musical instruments for wind and percussion stand on tables and can be handled.

The colour displays which also add richness and interest to this big open space can be seen through the partition windows of the classrooms which surround it. Looking into the classrooms you notice the degree of control of colour and shape in the displays there. Instead of bright colours in restless competition, one colour has frequently been allowed to dominate. In one room a wall is covered in a plain coloured paper. On it, pictures and visually interesting items are mounted and displayed with large cut-out letters that can be moved about until the coloured space, the pictorial elements and the captions fit together as

a whole and align with one another. The teacher here has learnt how to design a classroom in a way which allows experiment and achieves visual unity.

Another classroom [5] is a sight of unusual richness. The end of the room glows with yellow from a wall against which is placed an old black

[6]

rocking chair with a multi-coloured crocheted seat cover. A group of children are drawing it, building up the tones to show this clear-cut shape dark against the bright yellow background. In another part of the room a Victorian oval metal birdcage, painted white, stands upon a scarlet tablecloth. The white lines of

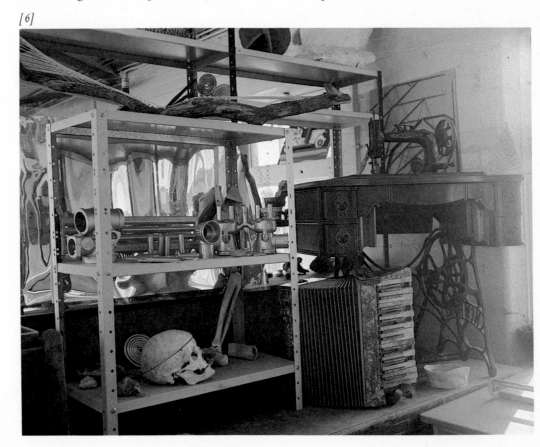

[5] opposite

7

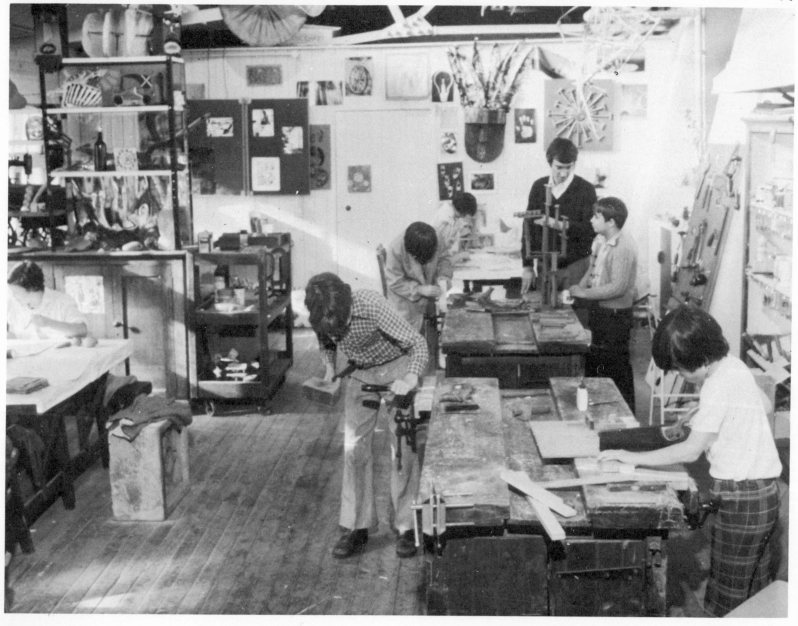

the cage cut up the red background in such a way that the children are made aware not only of the white pattern of the bars but also the red shapes between. (Artists call this the field/ground effect.) Another group is drawing an old army telephone – dug up in the school grounds recently. Although this is a complicated black machine, it has no daunting difficulties for these children who have the skill to

[8]

make their hands record what their eyes see. They enjoy the detail as they build up the drawing, sometimes over several hours. Another group has chosen to draw some brass balancing scales. They are admirably displayed against the scarlet cloth. The modern furniture in this classroom, the grey tables and the black and grey metal chairs offset the scarlet on some of the tables and help to give relief to the eye.

Other walls are characterised by different colours, the background paper chosen to suit the subject-matter of the displays. For example, a pale blue background is the setting for a display about the sea where photographs and reproductions depict waves and seascapes. On the table below are all kinds of shells and sea urchins to handle. On a hot-coloured wall is a photograph portraying a large red sun which has triggered off some dramatic sky paintings, individually expressed and showing an imaginative approach.

In order to promote various ways of using the brush to obtain certain effects, the teacher introduced work cards which involved the children in looking carefully at reproductions of paintings and studying the way they were painted. Some work based on the techniques of the Impressionists was very successful and revealed the child's ability to select and simplify the style he discerns and make it his own.

Another feature is the work done in connection with the local church which had been demolished. A university research student had been studying this particular church during European Architectural Heritage Year and had lent the school some splendid photographic studies of the building. These inspired some written work from the children who had made their own study of the site. The value and variety of the previous art experience showed in the quality of their drawings, developed over a very short, intensive period of work as the demolition proceeded.

They were used to concentrating on looking and representing, using charcoal for large, rapid statements with little detail and ink for more meticulous, patient work – the drawing medium influencing the approach. To help the children to start a drawing the teacher taught them ways of organising their observations. Perhaps, for example, they looked first at the dominant edge of a building against the sky. They really became involved in describing and naming architectural details such as porches, crockets and fancy brickwork. Gradually they fitted together the patterns of the building,

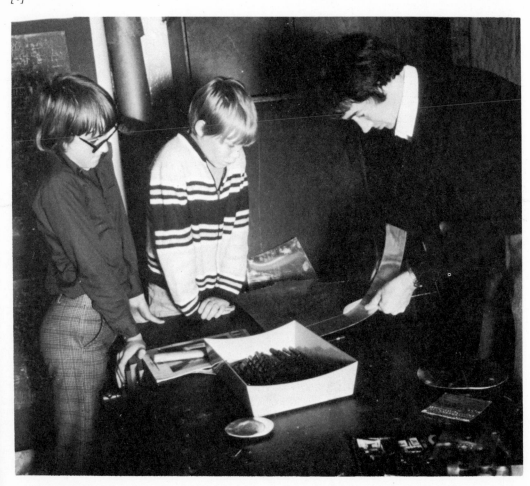

emphasising characteristic features as they caught the eye. This is different from an adult approach to drawing which may aspire to represent the structure of the building in related proportion.

A temporary classroom, situated near the corner of the playground and no longer required as a class base, still has a use. Someone had the vision to give it new life by making it into a craft workshop and store *[6]*. It is more than this – it is a kind of working museum as well. There are old glazed drain pipes, pottery chimneys and an Edwardian sewing machine embellished with gold transfer decoration. These objects, and many other natural and man-made ones, are arranged on open shelves to encourage handling and close examination. This is a place for activity, a room well organised for making things *[7]* not somewhere just for standing and staring. Areas are clearly defined, for clay, for wood, for metal and for print making. Tools can be easily replaced on wall pegs and quickly accounted for. Visual reference material is labelled and filed. Different kinds of yarns and strings on bobbins, threaded on a rod suspended from the roof beams, can easily be unwound and cut for use. There is room for about 15 children, working on a variety of jobs.

Two boys had made a paper propeller and winding device, housed in a small box, and operated by wind power. Another boy, absorbed in the engineering aspect of the job, was building a wooden frame construction. His aim was to achieve height with stability. Several alternatives were open to him and he was, in fact, making rules for himself about the design as he went along. These boys are able to develop simple ideas in science because of the confidence with which they handle materials. Through this kind of working, children of this age grow and develop, for they want to make things well and need to learn how ideas are modified by the materials used to give form to them.

On the other side of the room, two boys were being shown how to cut through thin metal sheeting with a pair of shears designed for the purpose *[8]*. The teacher revealed that he himself was learning how to fashion this material and had spent the previous evening with one of the parents who was in the trade. The children's attitude expressed their total involvement in the teacher's performance. The craftsman teacher had to analyse his skill patiently, in order to show how the processes work and help the children through a great deal of practice to piece them together and to make the skills their own. Here was teaching and learning that depended upon watching and copying, practising and remembering and gradually acquiring an aptitude for the job. A group of girls were developing a feeling for the plasticity of clay as they moulded pieces of decoration in relief and attached them to the tiles they were making. They had obviously been shown the technique by a craftsman. Another group were sawing wood at the benches. They had been taught how to use the saw rhythmically and how to place the wood against the cutting board or in the vice. The teacher would claim that the quality of work done in this school was due to the stimulation provided by the working environment together with structured experiences in a carefully planned four-year course.

School Two

Number on roll: 135.
Age range: 5-11 years.
Large mining village.

[9]

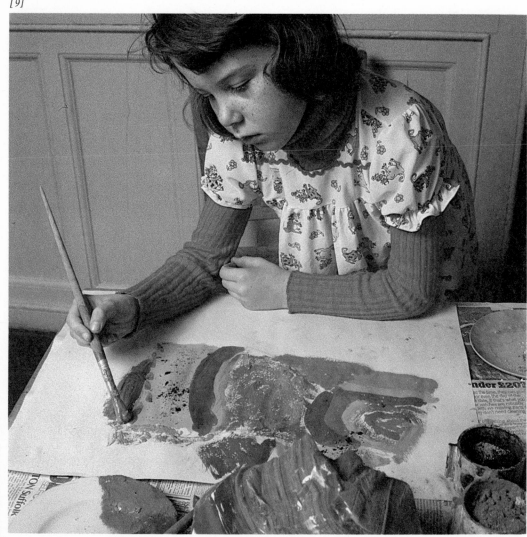

The school stands at the top of a ridge, looking as though it had grown out of the hillside. New terrace houses wind their way up the slope, gradually replacing the derelict ones which have the paint kicked from their doors, the windows obscured by boarding, and rubbish accumulating around them.

Children living in this monochrome, disintegrating, visually changing industrial environment find compensation as they enter the school. Arriving from eight o'clock onwards, they immediately start work on their murals, models and constructions. The teachers guide the children through their creative work until mid-morning.

Any visitors arriving at this time and passing through the colourful displays in the entrance corridor into the central hall are stopped in their tracks at the sight of groups of children working together: some on large-scale models using chicken-wire and fabric, others painting very large murals.

Much of the work in the curriculum originates from observation and the interpretation of what is seen. The interest is not only in ideas but in how drawing, painting, textiles and three-dimensional materials can be used to express them. Teachers develop the work by encouraging children to select an appropriate material and to work with it in craftsman-like ways.

One group of 8-year-olds being taught to mix and control colour were carefully blending pigments to match a lump of coloured shiny glass [9]. Another group were similarly engaged trying to depict with brushes and paint a variously textured and lichen-encrusted log. The excitement of varying the wetness and dryness of the paint and exhaustively exploring the brushes as tools was clearly to be seen in their faces as well as on their paper.

With the older children, drawing and painting are brought more together. Pieces of card, sponge, shaped wood and cork are tried out and used as 'tools' to translate ideas into reality. The children have become dextrous as they cut, stick and sew fabrics. One 9-year-old boy, having threaded his needle and made several stitches at full stretch, soon realised that he would have to pull the spare cotton through with his fingers. Alongside him a girl moved the needle freely over some foil on fabric as she built up an interesting pattern of different machine stitches with a sewing machine.

As the pupils get older the need for more time becomes crucial as they seek greater complexity of expression and demand of themselves higher standards of execution and visual awareness. The staff recognise this need for additional time, but find they can make use of the work done in the service of other subjects, feeding into the experience essential elements of science, mathematics, environmental studies, history and language development. Children studying a coal-mine were concerned with all these aspects, and with the problems of construction when building their working model of a mine. Throughout the school, children are occasionally encouraged to work together in groups of three or four, each contributing ideas, particular skills and discussion topics to the final presentation.

The work was summed up by the teachers who said that art and craft stimulated the education of the senses, assisted children to take care over their work, to be honest with themselves in what is a personal committed activity and to observe closely, enabling them to build up a reservoir of ideas and images through direct experience. Art and craft also helped to develop a habit of personal criticism and the acquisition of skill through care and practice.

School Three

Number on roll: 440
Age range: 5-11 years
Outer suburb of industrial town.

Here there is a specialist-trained art teacher who takes the junior art and craft lessons in the afternoons. She also comes voluntarily at other times to display children's work, prepare materials and generally influence the work of the school, including that of the infants. The working area for art is a converted cloakroom between junior and the infant departments. It has the visual stimulus of an artist's studio. A giant sunflower grows from floor to ceiling with its head turned towards the playground window. The children are now familiar with the prickly, tongue-like touch of its leaves which they feel as they pass by. One group has been trying to match paint to the yellow of the petals.

Behind the working tables is a paper chest on which a selection of papers and drawing tools are laid out and next to these is a book of Munch's reproductions opened at the *Avenue in snow, Kosen* where the grey-blues, soft mauves and yellow-greens stimulate they eye. It had been used with some 10-year-olds who have made tree studies from coloured torn paper and are beginning to fit colours against each other in exciting ways.

Some 11-year-old pupils who have recently visited a nearby port are now studying fish at close quarters. Two plaice and some large prawns are produced out of a bag. One plaice has been partly filleted so that when it is held up to the light it becomes transparent, showing the backbone ribs and the minute skin markings. The children examine the orange-yellow spots on the grey skin. They examine the armoured shell of the prawns. They feel round the outside of the plaice. "What is it like?"..."It's sharp!"..."Well I like the smell"..."Yes, it is slippery."..."What sharp teeth the plaice has!"..."Investigate it gently – isn't it beautiful?"..."Now you must share them as

there are not enough for one each."..."Choose your materials carefully – you may need brushes of different sizes." They settle quickly, eager to begin. Some paint directly and some use pen and ink and some paint with ink and wash. "Add the ink to the water," the teacher suggests and she takes paper and shows one child how to sort out tones from dark to light. "I've started again – it doesn't seem right!" "Forget about those fins – you need the simple streamline shape first, then add the fins." And to another child "Get a feeling for the edge, it won't be the first statement which will be right – make your mistakes on the paper." It is noticeable that pencils are held to allow sweeping lines to be made and ox-hair brushes are used with a sensitive touch since pupils have been taught to allow the brush to make its own particular marks. "Remember there is no right or wrong way to paint," she is saying now. "When you've put down what you want, leave it." "Don't wander about if you haven't a job." "Tim – you bring yours here – this is the best you have ever done." "I was in the mood," he replies. At the end of the lesson there are some who need the model longer. "Yes, you can take it to the classroom to finish," she says and the child is undaunted by the smell. The class teacher is happy to cooperate. "Off with the newspaper as the next lesson is needlework!" Certain children clear away: each has his own task.

Another group of 11-year-old boys is working on collages. Some have laid their work on the floor and are cutting scraps of material to fit the shapes together like pieces of a jigsaw. "Draw with the scissors." "Find the shape," she says, "cut direct, Robert!" They search for a special character and texture in boxes of assorted colours. "Light over the dark gives a stronger effect – look!"..."And there is more

colour-change by overlapping – see!"..."You can play over the sewing at home with beads and things." "After you have removed all your pins," she went on. "Draw with the sewing machine. Well, you may have to find a friend to turn the handle for you." "There, you have put too much glue on – we cannot get the needle in!"

Teaching art and craft is a non-stop business: both the organisation of the work and the teaching are demanding. This teacher had packed four lessons into the afternoon and when school was over a surging group of 8-year-old juniors came seeking advice about their weaving before the bus came. The cardboard loom weaving had grown wonderfully since it had been taken home and perhaps admired. It had now absorbed a variety of things like feathers, beads, grasses and branches as well as bright coloured woollen threads. "Push the feathers up tightly . . . fill the empty spaces . . . be a bit more adventurous . . . oh! that's a rich colour," she commented as each one showed an individual effort. Each child's work requires the teacher's individual diagnosis and comment.

School Four

Number on roll: 101.
Age-range: 5-11 years.
Decaying area in the centre of a large industrial town.

This school has splendid displays. They are not only looked at but also used directly in the children's learning. There is a working display [10] on the topic 'tools and machines'. It all began because the deputy head had brought to school some beautiful old hand-made tools that had belonged to his grandfather, who had been a wheelwright. The tools included a grooving tool, a spokeshave and a rebating tool and the older junior children enquired about their use. These 10 and 11-year-olds started to make a collection of old tools and rusty parts of machinery that they found on the nearby scrap heap. Shapes were compared, the purposes of tools were discussed, particularly the old ones not now in use. Interest grew with discussion and a topic was launched. A plan was worked out based upon five main categories of manipulative processes involving tools and machines. These were: the axle and the wheel; the lever; the wedge; the pulley; the screw and the inclined plane. With these categories in mind, the children [12] are busy examining an old bicycle in order to find out in which categories the different parts of this machine belong. For example, it soon became clear that the handlebars were 'levers'. The group became intrigued with the connection between the pedals and the chain. They discovered that the chain moved by means of the cog-wheels. Then the question arose, "How do the pedals influence the turn of the wheels?" This was answered by turning the bicycle upside down and examining the pedal movement. They came to see that there was a relation between the number of cogs in the cog-wheel and the number of revolutions of the bicycle wheel. So mathematical calculations came into the business of finding out by looking. Next they needed spanners to undo the nuts and screws on the bicycle in order to

examine the parts. At first the children did not know how to use these tools. But they gradually found out that by using the right-sized spanner, they themselves provided the lever for pushing or pulling to undo the screws. They had previously associated hammers with casual banging on the surface. Now they found out that some hammers have a claw at one end which

[10]

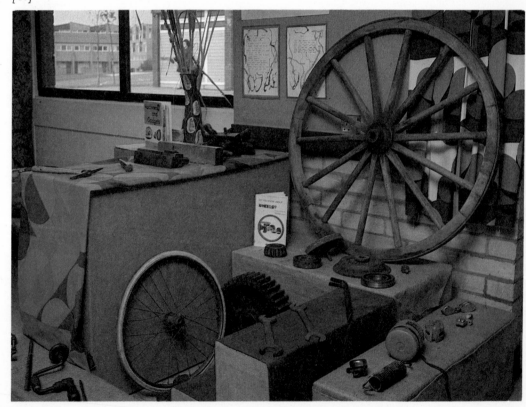

acts as a lever. "They began to think of tools differently," the teacher said, "to handle them with more respect since they knew more about the way they worked. They could now choose the right tool for the purpose." Someone saw the connection between the parts of the bicycle and the tools they were using to undo it. For the bicycle, they found, is

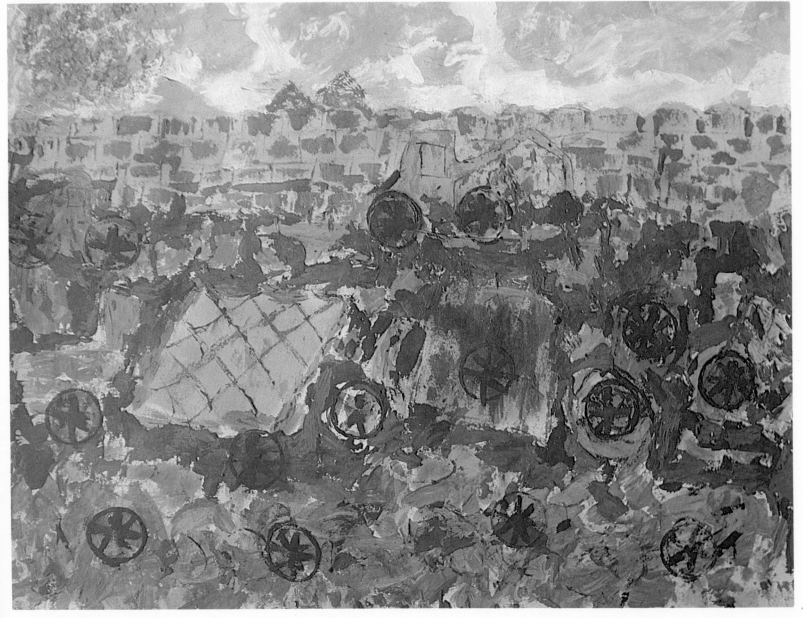

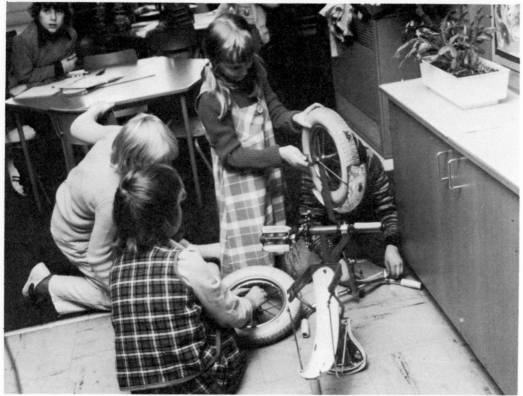

[12]

typify tools and machines. Blue-greys, browns, blacks, silvery whites and brilliant oranges, and of course rust colour, made up this scheme. The children said that green was a colour associated with plant life and not really appropriate in this context. They certainly used the colours of their own environment [11] brown mud, the dull red colour of the brick with the blue-grey haze and whitish mist that invest the industrial sky-scape with muted tones. The colours in these paintings reflected the strange feeling of desolation caused by the demolition going on around the school.

One child used the shapes of tools and cog-wheels symbolically and tried to give the impression of movement. Someone suggested trying to print with the actual tools. So a drill was painted at the edges and then rolled over the paper. To the children's astonishment the cork-screw curls produced a series of straight lines! The fascination of print-making gripped the class and thematic pictures were built up in this way together with the use of paint and even collage in which objects were stuck on to the paper.

Then came an interest in the lino tool itself as a means of drawing. The way in which the surface of the lino made a print, leaving the cut-out part white, much surprised the 10-year-old children at first. So another discovery was made through direct experience, which might lead to a study of the reproduction processes of the advertising that surrounds the children daily.

There was no doubt that observation, followed by thinking and talking about the goals they had chosen, enabled these children to take their studies further. The education of the faculty of vision, which is part of art education, is brought about by this kind of looking and finding. The statements made about these discoveries in drawing, talking and writing are vital acts of communication by which progress is made.

based on wheels, axles and levers and the hammer has a lever too! They enjoyed thinking about the categories to which these everyday tools and simple machine objects belonged.

Later they constructed ramps in various parts of the class area as inclined planes. Then some simple models were made in the hope that they would actually work like machines. Some of these were made from scrap materials and the most successful was the paddle steamer which did really 'go'.

Detailed drawings were made of some of the rusty bits of machines and old tools that were found on the demolition sites like the one where the old school had stood. They examined how the rust had corroded the original shape of the object bringing about a magical kind of change – a metamorphosis – and this seemed to catch the children's imagination as they drew with diligent detail, building into the drawing a host of marks and dots using pen and ink and other media. To show what they observed these children evolved a particular way of painting, building up surfaces to give a jewelled effect, full of minute pattern, as they became interested in the textural quality of the surfaces of the objects and the dissolving of one shape into another.

This led to discussing colour schemes which could

School Five

Number on roll: 250.
Age range: 7-11 years.
Inner-city school surrounded by decaying and vandalised housing. The catchment area consists mainly of local authority housing including high-rise flats for families, and multiple occupancy private housing for many of the rising number of immigrant families who provide about half of the school population.

This gaunt, old three-decker building in a decaying inner-city area probably offers for many children the only continuous security they experience.

The multi-racial junior school is full of hope and excitement. The formerly bleak school yards and wet-weather open-sided sheds have been transformed by large-scale wall paintings and inside the apparently forbidding building all the staircases have also been decorated in vigorous style [14] [back cover]. Most of the paintings have been designed and executed by the children with guidance from students at a nearby school of art.

This positive contribution to the environment is continued through displays of current and past work in the circulation areas and in the classrooms. The whole place abounds with sensitively organised presentations of drawings, paintings and prints. The children's models and constructions are set in appropriate surroundings, sometimes alongside source material or their writing or mathematical diagrams. Pictorial reference, books of quality, loan materials from a local museum and many other objects brought in specially by teachers and children (such as shells, pebbles, rocks, mineral crystals, mechanical and electronic bits and pieces, stuffed birds, mementos from other lands) are handled, talked about and subsequently used as the basis for practical work.

Carefully considered drawings of small-scale objects in pencil and ink were displayed in the classrooms. There was a quality of precision in observation aided by the choice of suitable drawing tools. An ambitious drawing of the complex view through a window across jumbled roof-tops had

[13]

rightly been given a special place in the display in the classroom used by older children. Some of the immigrant children brought a strong colour sense to their painting. This was fostered by the teachers

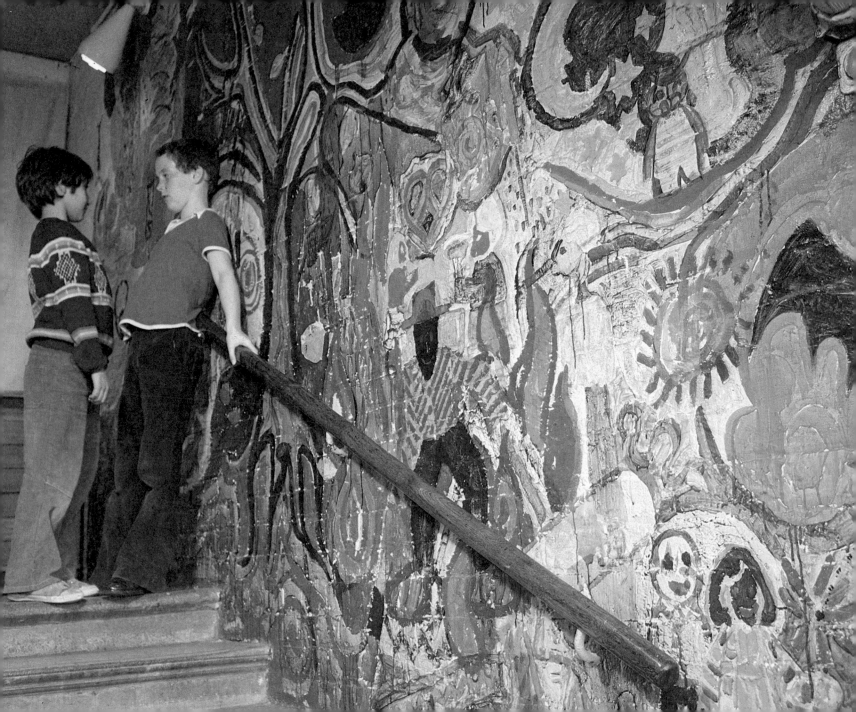

who provided paint with a range of colours and consistencies which together with a good collection of brush sizes and papers enabled successful work to be achieved in a wide variety of sizes.

"Success in art gives a wonderful new confidence to my children. Many of them are from deprived homes. Art inspires the children when they see that everyone can succeed in at least *some* aspect of the work and they see by the carefully arranged displays

[15]

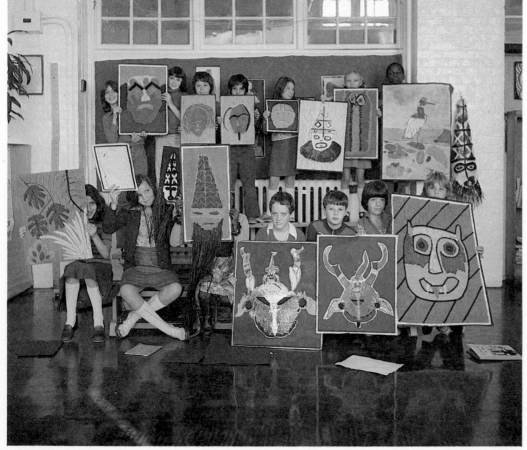

[14] *opposite*

of finished work that what they do is cherished." (The deputy head.)

Space which has become available because of the falling roll has been thoughtfully utilised to provide attractive work areas [13]. Necessarily messy activities are sensibly separated from places for clean, quiet work. There is a feeling of order and appropriateness everywhere.

One of the class teachers said, "The things we look at and handle give us opportunities to extend language experience far more powerfully than simply relying upon reading books. Talking is important beforehand, during the development of the children's work and afterwards. This often takes the form of seemingly informal discussion between me and small groups of children as well as among themselves".

The school makes good use of outside resources such as the excellent Education Centre of a nearby museum, where the skilled museum teachers work closely with the school. Fifteen visits have been made by different classes in the past year. Proper preparation is made on both sides. During the visits close examination and sometimes handling of objects goes with discussion and study of selected slides and film. Then follows drawing with a range of media and more conversation. The drawings and ideas are then carried back to the classroom where supplementary materials including carefully chosen books from the local library service offer additional enrichment.

There were some outstanding results following a visit to the museum when a class handled, discussed and drew a small collection of ethnic masks. The children's subsequent work in school, making powerful life-size masks and writing about them, was enjoyed by all the school at a special assembly [15] which included a small group of invited parents. The need for clear explanations is taken seriously by the children and helps further to develop their confidence in themselves, in their spoken English and in the value of their work.

"Art is the most important activity for my children. It is the basis, the springboard, for many other learning experiences. Art extends everything. It helps to develop concentration, it develops manipulative skills, it sharpens awareness, it widens time and space in the classroom and beyond. For my children the adventure of contemplation, choosing and experimenting brings a quickening of sensitivity which makes us all very happy."

School Six

Number on roll: 160.
Age range: 5–11 years.
The school is in a new building in an old village now on the edge of a small town.

The classrooms in the junior department are paired and each pair has two teachers and over 70 children. Some areas of the school are used for widely differing kinds of activity as the need arises: for example, a dining area is sometimes set up with sewing machines and used for needlecraft.

There are beautifully presented displays of children's work and teaching displays intended to attract and stimulate pupils. These may be of fabrics, pictures, tiles, stones, artefacts both antique and modern, anything giving to children sensory experience which may be capitalised by teachers.

In this ordered but rich environment children know where to find whatever tools, instruments or media they may wish to use. All these they are taught to use safely and appropriately, replacing tools when they are finished with and clearing up any mess which has been made.

The head sees his role as that of the 'consultant' in his school. He stimulates and leads discussion among his staff on all aspects of the primary school curriculum. He works alongside the staff so that the teachers see his approach to children and to art teaching. "The head should and must teach," he says. "He must show that he is a good practitioner, aware of the adults' feelings as well as of the children's." He believes that the association between the teacher and the group provides opportunities for the interaction which may ignite the creative process among children. "Usually the sensitive adult acts as a catalyst within the group and may modify the children's reactions, leading them to a deeper awareness of the possibilities in any situation." The teacher is aware of the gradual increase in the span of absorption in any one activity. "When the child

thinks his task is finished, it may well be. But teachers have to become aware of the ways in which the experience can be prolonged or deepened." Thus teaching depends on observing children. "An experienced teacher knows when a child is coming to the end of a creative span. The child may ask for guidance but the asking is not necessarily verbal. He will signal the need for help or guidance, or even redirection." The adult has the task of "linking the strands of relationships, thoughts and feelings to enable the knowing to become thought and speech. This is experience shared."

[16]

The teacher leads a group of pupils, finding a fruitful area for observation and indicating the compass within which work may be undertaken; when pupils work outdoors the area is chosen by the teacher. Pupils select from within this compass the aspect of the area they wish to study: natural or man-made. The teachers support and guide children, they aid choice and help pupils steadily to improve their ability to focus, they sharpen their pupils' use of communicative skills [16] as slowly the children learn the process of selection.

One 9-year-old girl had been looking carefully at

trees. She drew what she saw, becoming aware of the texture of the bark and arrangement of the branches. A painting followed from this direct experience of recording. Then, using reference books, she made a more general study of trees. This led her to make a collage embroidery, involving the careful choice and arrangement of materials, threads and stitches and the use of an electric sewing machine. During the course of the work she had to make many decisions based on her direct experience of the tree and her further study.

Four pupils in the top junior class, in pairs, painted large pictures of a bouquet of flowers presented to their teacher, who had remarked that a painting would remind her of the occasion after the flowers had died. The class discussed the qualities of the flowers, the composition of the bouquet and the effects of the juxtaposition of the different shapes, colours and textures of the flowers. The four children selected the paper they intended to use and the teacher advised them on proportion and arrangement. To help to reduce the problems caused by artificial light she placed a dark sheet of paper behind the bouquet. The two resulting paintings were equally successful but totally different in execution even though the four children concerned had much experience in common. These young painters could discuss the various techniques of painting with confidence and accuracy, employing a vocabulary which reflected their skill and experience.

Following the class discussion which preceded the painting another child went into the quiet study area to recreate her perceptions in words. "The chrysanthemum is either a cinnamon colour like a rusty fence or like the sun sending down rays of sunlight."

Considerable organisational ability must be exercised so that the teacher can find time to deal with individuals and small groups. "Each person sees and enjoys different aspects of visual experience and therefore reacts as an individual in response." The head advises, "intervention will take the form of reminding the pupil of what he has seen and discussing how he means to express this image on paper."

In this school, children produce their own books containing writing and illustration [17], sometimes accompanied by paintings, drawings, prints and models. Each study may last for a term and each pupil usually has two or three such books in hand, according to his capacity.

One 11-year-old boy produced a book which was primarily concerned with mathematics though on this occasion the common ground between art and mathematics become clear in the preoccupation with order and pattern which is common to both. The boy had used graph paper to enlarge drawings and shown in these his understanding of scale, proportion and distortion. Cutting accurately and fitting together the patterns of triangles to form coloured octagons exercised his craftsmanship; his sensitivity was sharpened towards relationships of colour and form. The book itself displayed meticulous craftsmanship with its cover design based on a symmetrical pattern derived from a Mediaeval tile.

Perhaps the most important factor in the work of the school and the quality of the products which result is the head's understanding that children need much time and experience with the various media employed so that they can be confident enough to communicate what they wish. They must become thoroughly absorbed in the subject matter and deeply involved in the processes which give form to it.

The staff follow the head's guidance, modelling and adapting his approaches to themselves until they become their own. They form their own convictions, from which they teach and which give the work of the school an obvious diversity within its unity.

[17]

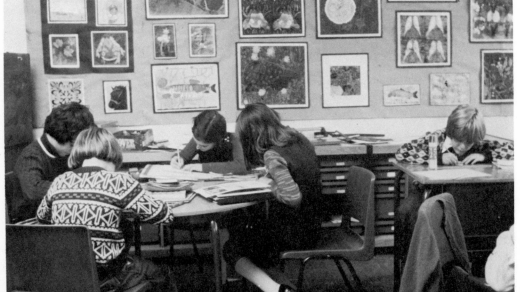

School Seven

Number on roll: 280
Age range: 5-11 years
On the edge of a market town, overlooking farming country.

[18]

The head believes that deep and sustained involvement in art and craft activities is most important for general educational progress. She provides for a limited range of traditional craft materials to which the children can return repeatedly between the ages of 5 and 11 years. There is no work assignment system, but instead, a flexible 'give and take' method prevails, which allows children time to finish work undertaken and teachers time to follow up special interests voiced by children during general discussion periods. These may involve children in writing, making, finding out, assessing, thinking logically or describing poetically.

The guidelines compiled by the head and staff in consultation indicate expectations at certain levels. The teachers keep careful records. In art and craft, elements such as observation, muscular control, ability to use certain media and to manage certain crafts are noted. School visits are recorded with entries such as "Field study with wool group for spinning and dyeing, followed by an extended period of weaving her own wool". The main measurement of a child's progress is in the samples of work kept each year for this purpose. Such an organisation allows flexibility and safeguards a balanced curriculum where individual progress is recorded systematically.

A special feature of the school is the organisation of the open plan areas, making maximum use of two practical bays to provide special work spaces, one for juniors, the other for infants. Each bay can be used for art and craft by any group or individual who needs its resources. The infants' bay is laid out for clay, wood and painting. An infant teacher is responsible for the care and safety of the woodwork

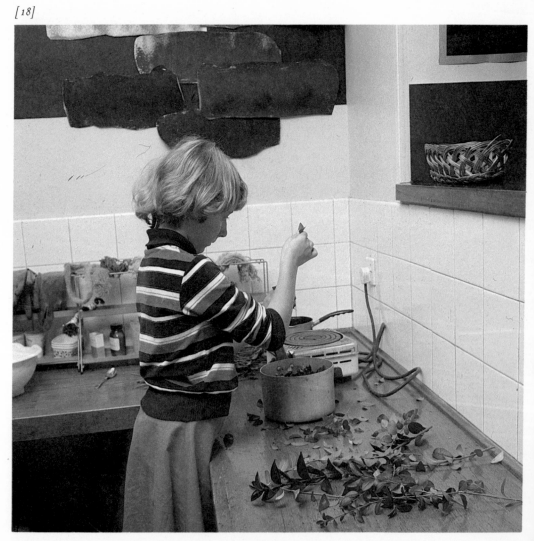

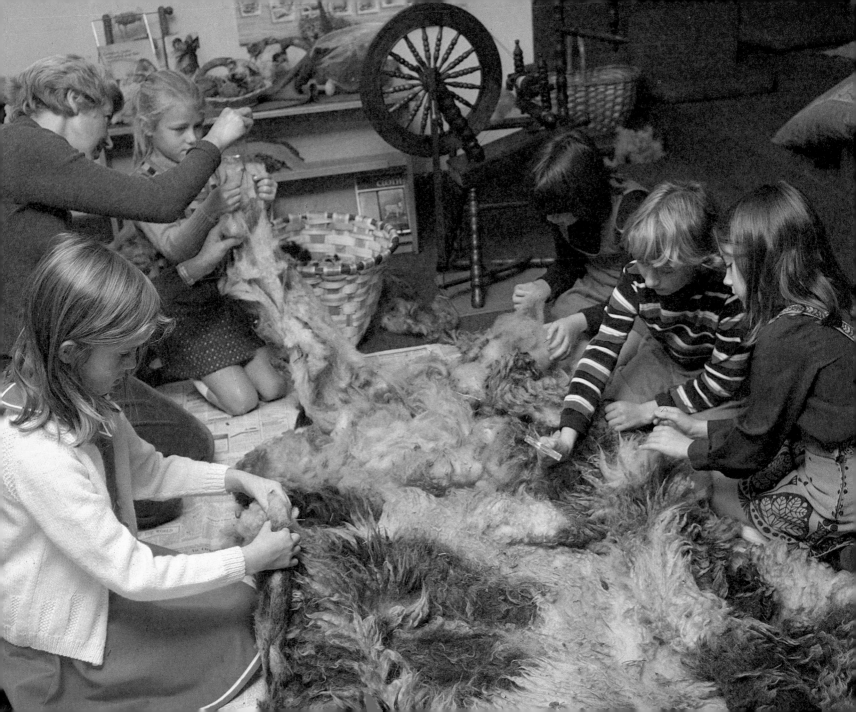

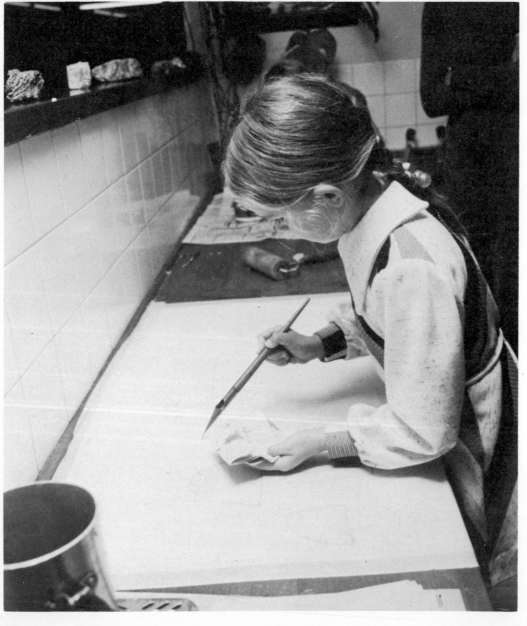

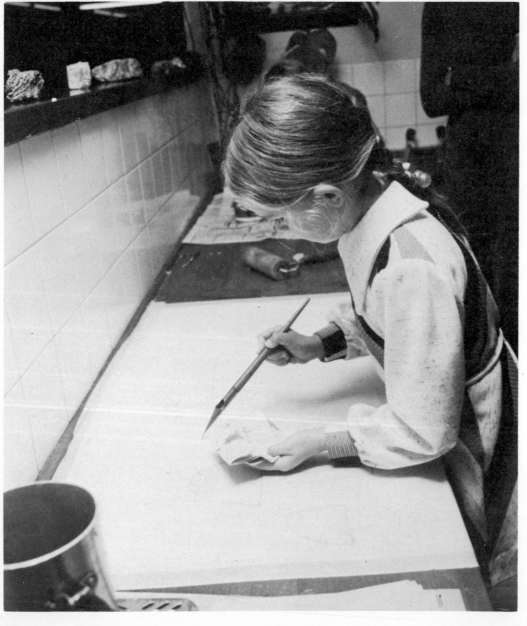
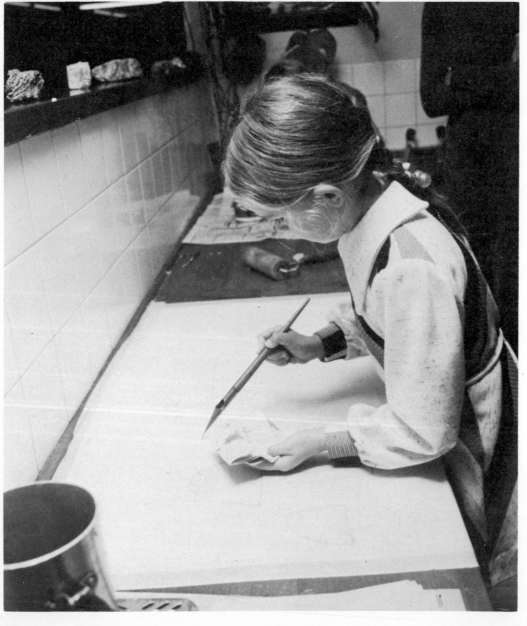



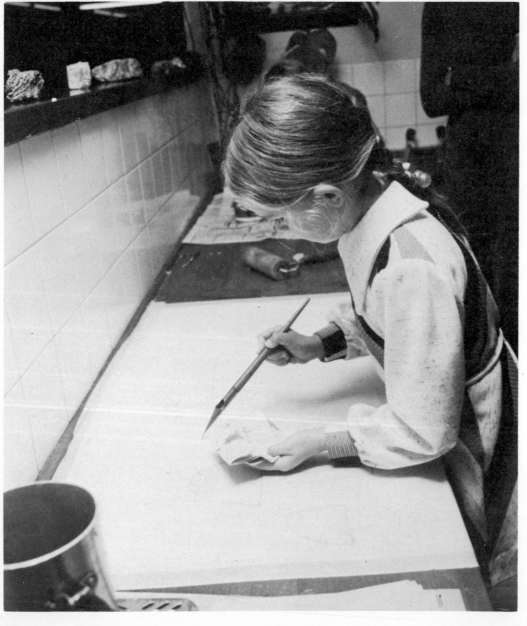

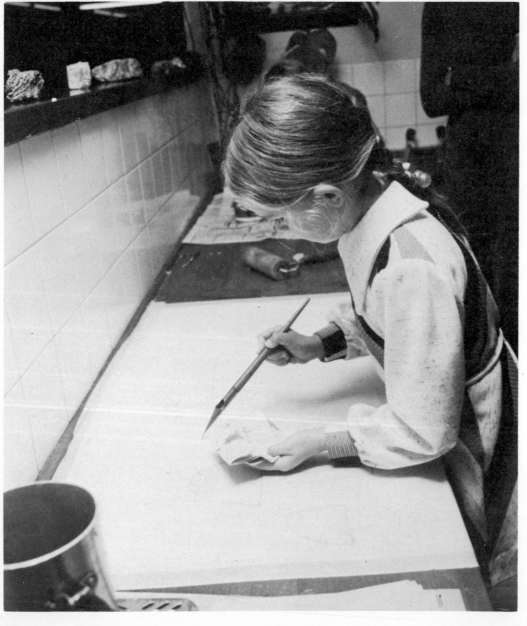

[20]

tools here and a junior teacher organises the kiln firing. The junior practical bay is equipped for textile printing, painting and vegetable dyeing as well as for collage, embroidery and batik. The teacher is keeping an eye on the electric double saucepan of hot wax and the hot plate for boiling dyes. A girl *[18]* is preparing privet leaves in the juice of which she will dye her spun yarn, hoping it will become a soft green colour. Another child working in this area *[20]* is drawing her design on the cloth with the appropriate tool as naturally as if she were using a pencil.

The spinning wheels, spindles, carders and fleece and other materials are kept in another room. Children are examining a whole fleece *[19]* and noticing the different lengths and quality of the fibres coming from different parts of the sheep. The school keeps two sheep who graze in a fenced-off part of the school field. The year-long study of these animals enables the children to follow through the study of this craft with its implications for farming in this area. They do not have to resort to work-book exercises or to the mass media for source material.

The young girl spinning *[21]* has just achieved a beautiful long thread. For the first time, on her own, she was brave enough to jump her fingers up the unspun fleece and allow the spin to eat its way up into the fleece without clogging. Earlier she had squeezed the unspun wool tightly at the top, fearfully controlling the small amount she let out to catch the spin and actually preventing it from running up to make the thread, making it more likely to clog and break through over-spinning. This child has just reached a new level in craftsmanship. She is now able to 'go along' with the material and the process. She is becoming one with the instrument and its rhythm. She is working as an adult craftsman would.

A home bay houses the looms on which certain children can be seen working independently *[22]*. They have made some of the looms themselves, including primitive ones with their warp threads

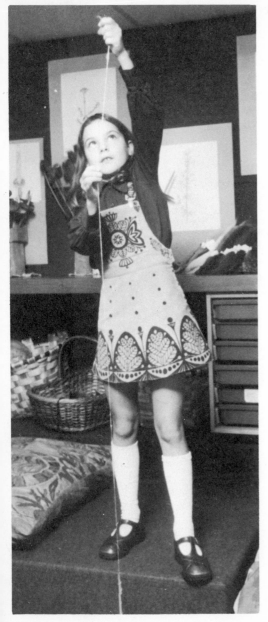

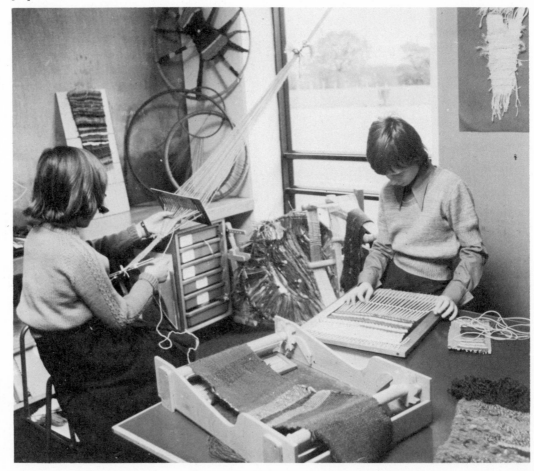

weighted down with stones. The table area in here can be cleared to allow a group to write notes, perhaps on the history of the craft, or to record accurately, in their own words, the processes involved in their chosen craft. The teacher may introduce the subject and write some of the more difficult words on the blackboard. In this way the children learn specialised terminology like warp, weft or woof; fleece, a staple of wool; a woollen or a worsted thread.

Work of a different kind is going on in another bay [23]. Notice how the small boy is using the woodfile with his finger straight along the edge steering his performance. He has watched and learnt and made this little bit of style his own.

It was interesting to find how responsible the children were in finding and in returning the tools and materials to their appropriate places. The whole system of sharing the rich resources in this school depends much upon a reliable and responsible attitude from the children which experience in craftsmanship does a great deal to foster.

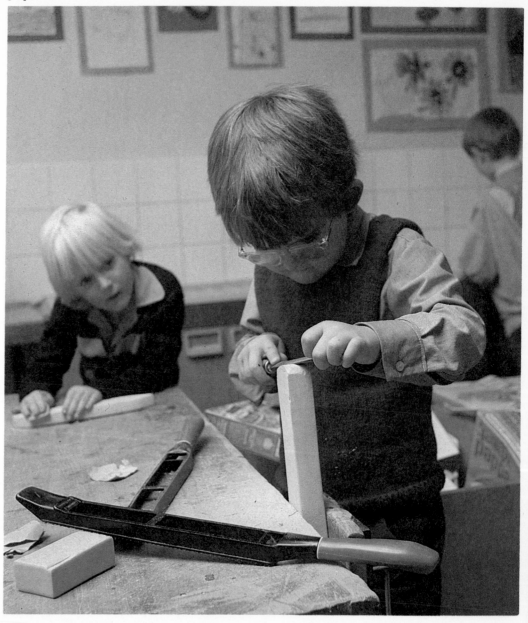

School Eight

Number on roll: 570
Age range: 7-11 years
Overspill estate in a provincial town.

[24]

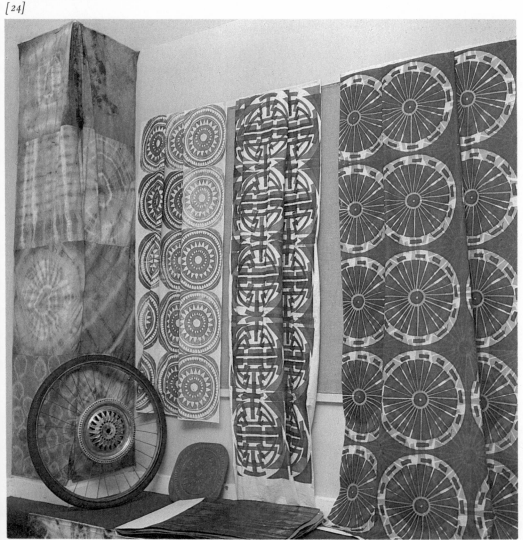

The consistency in the standards of display *[24]*, both of children's work and of inspirational and resource material, is remarkable. Moving from the classes of first and second year children to those containing third and fourth years, it is possible to see, instantly, that there is marked progression and that in most rooms the subject maintains its impetus and status. Art and craft activities are carried on in normal classrooms – there is no special room – and are integrated thoroughly with the rest of the work. These teachers attach great importance to first-hand observations and recording as a basic approach to all learning and this means that drawing is well developed. The use of pen and pastel as well as pencil, paint and other media shows growing sensitivity and the effects of these experiences are clear in much of the painting and fabric printing.

The school keeps chickens *[25]* and the first-hand study of their life-cycle gives rise to a great deal of detailed work. A splendid screen print shows the confident translation of a drawing of a cockerel into a strong printed image *[26]*. There are also sensitive drawings of chicks *[front cover]* and feathers *[28]*.

One of the senior members of staff responsible for a class of 10 and 11-year-olds maintains that looking by pupils should be purposeful, but looking has to be learnt. The teacher's task therefore included the need to direct attention to such things as proportion ("How does this length/width/size compare with that?"), to angles ("At what angle is A to B?"), to direction and to other elements of what is seen. This constituted a challenge by the teacher to the pupil; the teacher's skill in this direction depended on her ability to find the right words and to formulate the challenge correctly. The teacher needed to make judgements about the stage of development reached

27

by any individual child in deciding what that child could do at that moment. She was referring, in particular, to the coordination of hand and eye and therefore to the degree of control that might be asked of the child.

This teacher draws at the same time as the children, talking while she does so. She says she asks pupils to watch her eyes, to notice how much more time she spends looking compared with the time she spends drawing, asks them to notice how she translates an angle in the observed object to paper,

asks pupils to think about how she conveys solidity. Good observation and recording depend also on understanding the object observed. By this she means understanding the structure and function (of a bird's wing, for example). The challenge she offers also extends to the medium used by pupils: "What colour paper, what size, should be used?" "Is charcoal a suitable medium for this subject, or would pencil be better?" She attaches importance to using the recorded observations as the subject matter for development by means of other crafts – printmaking

[24] and batik [27], for example, where certain limitations are imposed by the medium and the interpretation requires sensitive adaptation.

This is a large school but the only class described in detail is one containing some of the oldest children, where the results of the four-year course can easily be seen. Almost any of the other classes could have been so selected. Such overall achievement indicates the skill of the headmaster in encouraging his staff to work with high expectations and consistency of purpose.

[25]

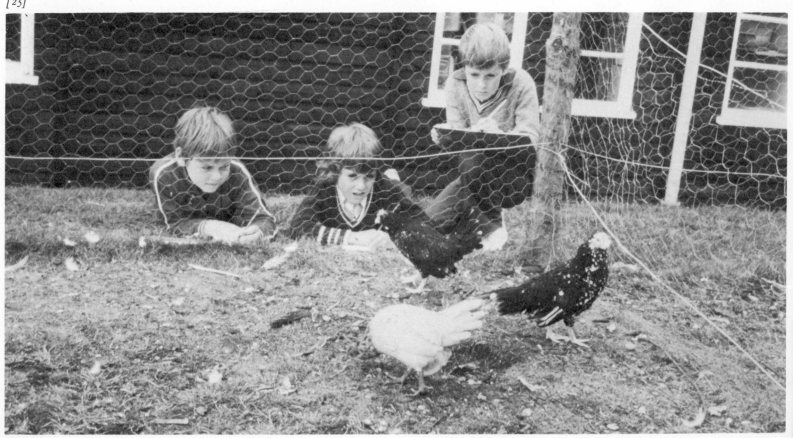

[26] opposite

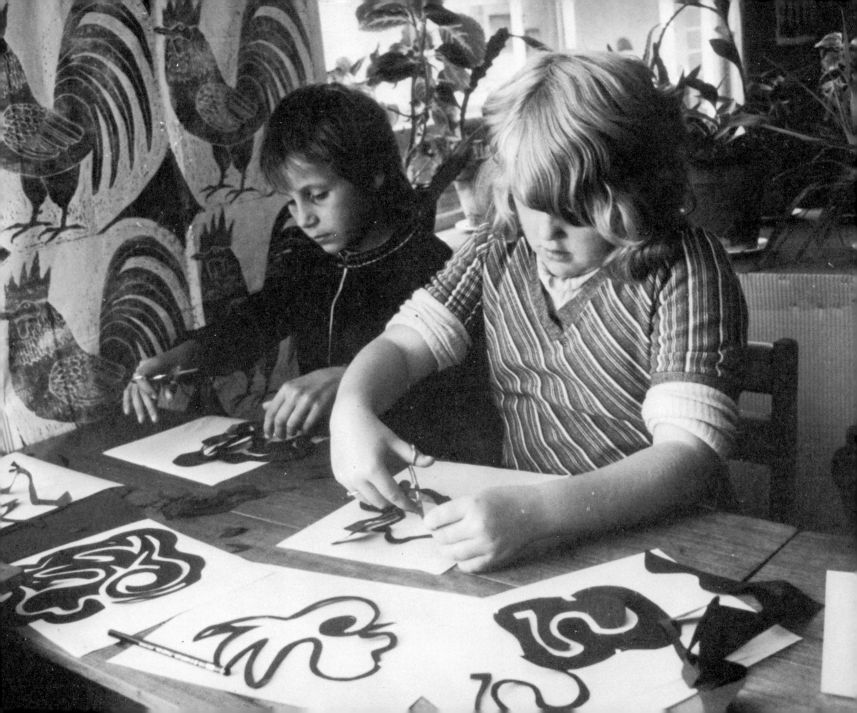

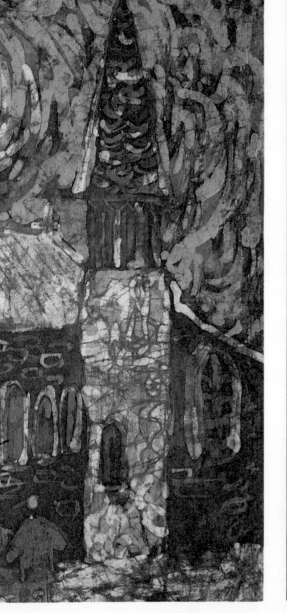

School Nine

Number on roll: 150
Age range: 5-11 years
Village at the edge of a provincial city.

[29]

The old nineteenth-century school has been well adapted to house two of the three junior classes and the way in which the new hall and classrooms follow the lie of the land on the hillside contributes to the character of the old village. Inside the school the colour in the decoration – the lofty ceiling a satisfying dark grey-blue – assists in the carefully considered educational environment. Children's work, mounted or framed reproductions related to current interests, ceramics and textiles, natural forms [30], museum objects and other items of visual and historical interest are arranged in the hall and passageways as well as in the classrooms. These arrangements are designed to give the maximum visual impact as well as to provide inspiration and reference for the work in hand. The rooms are well organised for different kinds of work. A cloakroom area with a large sink is the messy work-space for the older juniors and this is seldom without occupants engaged in print-making, tie and dye, batik, painting or preparing books to contain their written work and illustrations. Clearing up is an important part of the exercise so that the area is left ready for the next group requiring it.

The head maintains strongly that drawing is vital to the work in the school because the act of drawing causes the pupil to look carefully and hence to understand [31]. The language arising from this looking is the language required by the individual to personalise and fix the experience.

This small staff can readily exchange ideas and share skills. They regard the techniques of the crafts they offer to the children as essential tools of education in themselves. They are careful to teach children the procedures involved, at the appropriate level, gradually extending their prowess and

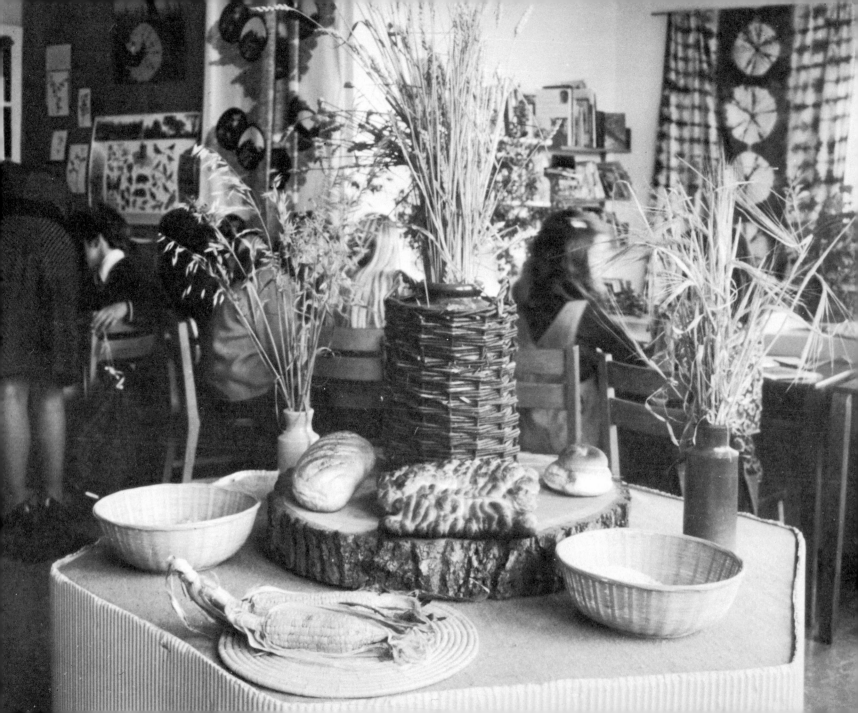

confidence as developing visual ideas require more advanced or complicated procedures. This is always done in the context of need – need usually arising from direct observation and the interpretation which follows.

Up on the hill the older juniors were looking at the landscape: the bracken and the autumn trees. Painting a picture from her notes and drawings, a girl asked, "How can I make the bracken crackly and crunchy?" The teacher discussed using the brush in different ways, with different pressures and movements, perhaps experimenting on a separate piece of paper. Bracken had been brought back in order to match the colours. This was easier to carry than the marvellous rocks and stones from the summer seaside visit. The study of these resulted in the splendid painting illustrated [29]. The torrent landscape [32] was painted following the same visit when some of the children were studying the river. Looking out of the window involved different problems: there was a limited view and working out the exact shapes of the road and buildings seen from up the hill was, for some, more absorbing than the texture of the trees.

The class visited an old house to make notes and drawings and to investigate its history. An 11-year-old printed a cover paper for the 'novel' she had written, inspired by the visit. Her drawing of the dove-cote, a strong feature of the story, provided a motif for a lino-printed repeating pattern.

Another kind of lesson was learnt by younger juniors. Making their books involved them in careful, clean, accurate work. They were given ready-cut boards so as to have a standard against which to estimate and measure the binding material and the cover, which they had previously printed and now had to cut to size. Handwriting is also carefully taught in the class and the finished books are easy to read as well as beautiful to look at and handle.

Other 8-year-old children had studied sunflower heads and made sensitive drawings with careful

attention to the arrangement of the seeds. Afterwards they drew the mathematical pattern they had discovered and the two types of drawing were mounted and displayed together. These children had also made screen prints of animals they were studying. This was seen to be a splendid way of translating a very simple drawing into a powerful image as it became a silhouette, well able to stand beside other more complicated renderings.

A visit to the Pompeii Exhibition at the British Museum in 1976 led to practical study by most of the children. They made historical and geographical investigations based on what they had seen of how the people lived, what they did and the things they made and used. To examine the architecture and technology the children constructed models; a group studying the bath house became engrossed in the logic of plumbing. Others reconstructed the pottery of the time or recreated pictorial themes using mosaic tessarae. Imaginative paintings of the city's final destruction, some as if seen from inside the houses, were allied to fine descriptive writing. In discussion the children revealed that they were already considering other problems: how did the ash preserve the shape of burned objects? How were the wall decorations painted? Did the Pompeiians print fabrics? How did they calculate with Roman numerals? The teachers were prepared for such developments with appropriate materials and sources of further information.

Conclusions

[33]

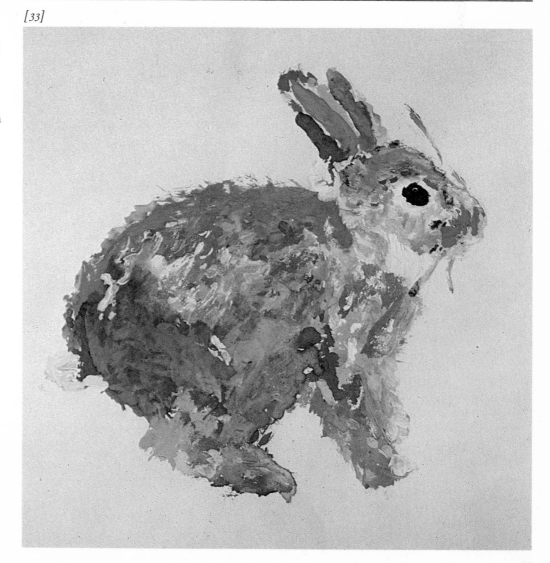

What can we learn from the experience of these schools? We feel that three major elements stand out. They are conviction, care and expectation and we must enlarge on what these can mean to a school.

The teachers in these schools were evidently convinced that art was a significant aspect and basic tool of education for all children. Work was based on direct experience and observation and the considered use of materials. Sensory experience, especially its visual and tactile elements, was felt to be an important avenue of learning. The children's consequent absorption and effort are clearly seen in some of the illustrations *[17, 23, 34]*.

Care was evinced through the good personal relationships between individual teachers and children. Care for the environment of learning was shown in the high aesthetic and cultural standards apparent in the visual resources offered; in the presentation of these and of the pupils' work; in the proper choice and organisation of practical resources and the progressive training in their use.

In all the schools discussed the teachers expected high standards. We saw work and attitudes which are more commonly associated with pupils of greater maturity; some of the work showed perception, imagination and performance which could be favourably compared with that at good secondary art departments. Examples can be seen in the drawings and paintings from observation; in the inventive interpretations arising from these; in the responsible approach to craft activities and the working atmosphere illustrated throughout this book.

Teachers and teaching

How do teachers become convinced that art is a fundamental necessity in primary education? Their own professional expertise has already made them aware of how children can learn through experience. Possibly the realisation of how their pupils' direct experience of visual and tactile phenomena contributes to art education depends on their own understanding and personal experience of art and the way it can be generated from visual, tactile and emotional experiences, from direct and indirect influences, tangible and intangible ideas, beliefs and feelings. Without the constant replenishment of

[34]

their resources of vivid and meaningful visual ideas, the content of the art and design produced will remain barren and impersonal. A great painter of the nineteenth century wrote of his "*sensation plus forte devant la nature*". Another in this century declared, "*Je ne cherche pas, je trouve*". It could be that teachers have been so impelled to identify with the work of artists and craftsmen that they can appreciate the power of communication without actually practising it themselves. But the personal practice of an art or craft enables them to know what it is like to feel creative and to practise the skills necessary to embody the idea in the chosen form. They may have had these experiences in childhood, in school, in initial training or during their teaching career. As by children, so by each individual adult the experience is received differently and each reacts differently. The common factor is that eyes are opened to a fresh view of the significance of often familiar things; to new and interesting juxtapositions of colour, shape and texture.

For teacher and child alike, this visual experience is frequently brought about by the act of drawing [35, 40], often accompanied by written notes. The practice of photography can provide a similar stimulus. This kind of learning from observation and interpretation needs time and practice : it can be helped by expert guidance. There is usually someone – a member of staff or a local adviser – who can provide this. The quality of the results on paper may appear variable, but it is through the simple process of looking with a view to drawing or photography that many visual qualities are seen and appreciated; ideas are generated and a host of possibilities opened up to be explored. The educational importance of art becomes clearer as people feel the expanding role of the expressive arts in their own lives and work. Furthermore, the understanding and enjoyment of the work of those who practise art and the crafts professionally is made more accessible. All this can be shared with children.

The teacher's sensitive observation of the way children behave and learn is another important influence. The natural curiosity of children is clearly expressed in their uncritical zeal to examine things; not just looking at shapes and colours, but picking up anything small enough in order to feel the texture or temperature on the skin and the weight in the hand. Similarly, children experiment with tools and materials, often discovering effects which, at first, give pleasure unrelated to practical usefulness. The teacher must be able to bring these two kinds of exploration together so that each can be used in the service of the other. An intense interest in the physical qualities of things can be directed towards

larger objects and wider issues where this kind of experience and the response it engenders is utilised for more specific investigation. The outcome may well be not only art but also increased scientific and mathematical understanding, together with all the wealth of language which real, shared experience can generate.

This was certainly the case in the schools whose work is illustrated and discussed, where language, art and many other considerations were equally important in the planning. The drawings of chicks [3, front cover], the painting of the rabbit [33] and the studies of flowers, feathers, wood and stones arose from this kind of learning through careful observation. Further developments can be seen in the translation of drawings into designs for fabric [36, 37, inside cover], the books [17, 52] containing complete studies arising from investigation and the three-dimensional constructions described in Schools One and Four. Educational visits such as those described in Schools Five and Nine depend for their full success on previous experience of this kind. A lead-in to architectural drawing is described in School One.

The short booklist on page 48 is offered simply to provide some background reading in the philosophy of art and art education. There are many excellent books on craft techniques which can be used effectively only in the light of firm conviction about the place of art in education. Two pamphlets on safety precautions have been included in the list.

Preparation and planning

The amount of thought and preparation which goes on outside teaching hours is an indication of the degree of professional commitment and understanding this kind of teaching involves. For instance, in an open-plan school the teachers expect to adapt their work daily to each other's programmes. They plan the next stage of the work, discuss

development and standards, write up records and prepare the rooms so that the children can start each school day without delay. In another school, the staff return before the beginning of term to prepare the classrooms, so that children in a deprived area return to a rich and stimulating place after the holidays.

In most of the schools whose work is described and illustrated, discussions on policy and progress take place regularly. Practical in-service sessions are devised in which staff share their conviction and their skills with their fellows. In some schools one or two teachers have a special consultancy role for general guidance and display. The role of the teacher as consultant within a school needs discussion in order to give it strength. Promoting progression is a crucial issue, and this may involve general educational considerations as well as specific help with practical processes.

Two of the schools whose work is described have specialist teachers: the rest have not. Each school was successful in its own way. Specialists sometimes teach more than one class in the school. Their knowledge can bring expertise and confidence into this area of the curriculum when they have an understanding of the needs of primary school children. In such a situation the specialist teacher works closely with the class teacher so that current interests and preoccupations can be utilised. This demands prior discussion and preparation by the teachers concerned. The class teacher can integrate art closely with the rest of the work, where this is appropriate, and use time for it in a flexible way. Many of these schools claim that all their work is integrated because of their convictions regarding the basis of learning. As with other subjects, the emphasis on art activities varies from time to time,

but as a basic tool of education and communication, art is always an important component. The use of the materials and skills associated with art and the crafts is seen not only in the presentation of their work, but in the very processes of observation and recording through which much of the work is achieved.

Local advisers have played a part in some schools, not only in organising practical courses or discussions, but by visits and encouragement, and sometimes by teaching a group of children. Art advisers in many parts of England are beginning to produce material to help teachers. This may take the form of suggestions for a sequence of work arising from a starting point prepared with certain specific objectives in mind and related to the stage of experience of the children.

Some schools may find difficulty in offering

[36]

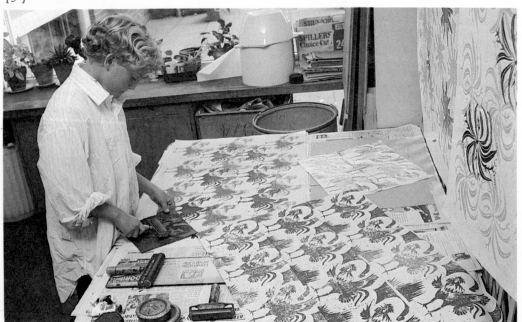

[37]

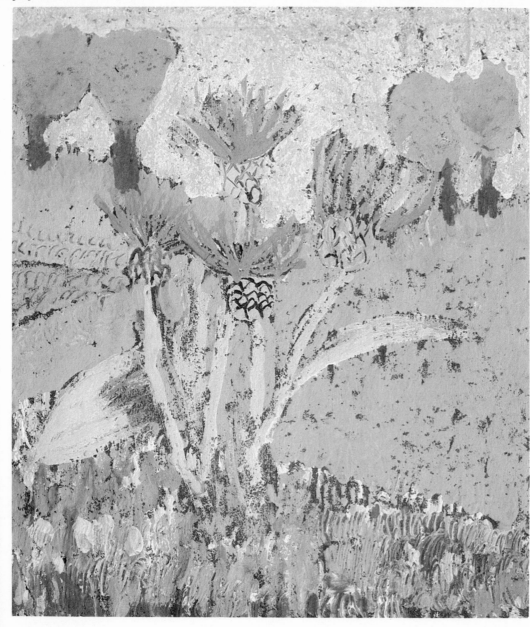

appropriate activities to engage the interest and use the capacity of the older pupils in this age range. A solution may lie to some extent in integrated work, such as that described in School Six, together with sensitive planning for a four-year sequence of developments. This, with the accompanying provision of resources and materials which allow for individual rates of progression, accounts for much of the success and the high standards achieved by the older children in the schools described.

However much teachers stress the importance of direct experience, the growth of manipulative skill and the competent use of tools and materials, they are themselves continually challenged by the growing diversity of activities in art and craft. When new materials or processes are to be investigated, teachers must consider possible dangers before activities begin. Written advice provided by

[39]

39

manufacturers and suppliers can be helpful: for example, some varieties of clays in their dry state give rise to dangerous dust; expanded polystyrene can give off poisonous fumes; glazes can release toxic metals if the pots are used for storage of food and drink; glass fibre and film processing materials can cause lung damage; synthetic resins can cause skin damage.

Arrangements must be made for good housekeeping methods: the regular cleaning of overalls, the safe handling of sharp tools, and other good practices which can develop a tradition of safety in school workshops. The potential dangers need not inhibit enterprising teachers, but it is essential that they should be aware of the risks involved so that they can ensure the safety of their pupils by careful organisation and close attention to the correct use of materials and equipment.

[40]

It is through the teachers' personal example that the children will learn to develop the correct attitude towards the materials and their use.

Reference materials and resources

The preparations outlined above imply not only conviction but the provision of resources of many kinds. The visual environment of a school is a continuous and unavoidable influence on all who come into the building. Many features are permanent and unchangeable but within these limitations a school is responsible for its educational environment. This is a visual communication comparable in scope with language in being expressive, practical and poetic. So schools need to display well-designed textiles and ceramics, natural and man-made objects, pictures, photographs, museum specimens and other reference material of quality; and, of course, books. Some of this is purchased, but in addition, teachers, parents and children contribute items to the school and class collections. For although adults may determine the overall appearance of the school, there must be opportunities for the pupils to make their impact. There will be evidence of the immediate interests of the day as well as what has been inherited from the past.

The purchase of consumable materials is a major item on the budget of any school and the choice of materials needs to be carefully considered, economically managed, and used with care. The good practice noted in these schools has not stemmed simply from the provision of a wide range of materials: it comes from the insight with which they are used. Often simple materials can be used in a telling way. When teachers provide any limited selection of materials certain factors need to be borne in mind: materials for both two- and three-dimensional work will be required. These should provide a range of visual and tactile qualities and variety in size, colour and texture. For three-dimensional work there may be resistant materials such as wood, which may require tools, as well as plastic materials, like clay, which can be shaped by hand.

Large rolls of cheaper paper are useful for murals and the more ephemeral work. Good writing paper is used to help in encouraging a pride in handwriting and page design. Much finished work is then bound into books, made and decorated by the children as an integral part of their project. Different colours, sizes and textures of paper involve children in discussing and choosing as described in School Six. Such considerations play a vital part in a successful painting. For the artist, an idea has a certain scale [39], colour [38, 43] and atmosphere which can be best expressed using material sympathetic to that subject matter and individually selected for it.

In one school described here, where the children's understanding of colour is carefully and systematically developed through observation, the head finds it necessary to order three times as much white as any other pigment. Without this it is not possible to modify the intensity of colour while retaining its opacity. The range of brushes provided can influence the quality of the work considerably. The varied uses of different kinds of brush and brush strokes with thick and thin paint are a continual fascination to children encouraged to experiment with them as they match colours and tones and indicate the surface textures they have observed. In all the schools described there was some emphasis on the different ways of using simple but important tools. Some very ordinary ones like pens, pencils and chalks can produce a great variety of effects. The disciplined use of a limited range of colours can give rise to subtle harmonies of hues and shades. Simple and more complicated devices for print-making, print-taking and rubbings involve children directly in the experience of textural qualities and all the language needed to describe them. In one or two schools the paper to be used for a painting is subjected to a texturing process so that the

background, from the start, has an interesting surface, against and upon which other effects can be built up. This is seen in the flower paintings [38, 43].

Traditional crafts, such as modelling and building in clay [41], fashioning in wood [23] and metal [8] and spinning [21] and weaving [44] with wool are all concerned with basic raw materials. These are an important part of our material culture and of the history of our civilisation. Much of the history of England is bound up with the wool trade and its legacy is to be seen in buildings and institutions. The crafts which may be practised in primary schools each have their own skills needing sympathetic exploration and development. The educational experience of making things through the manipulation of the characteristic tactile qualities of clay, wood and wool in their natural state can lead to an understanding of the design of functional objects in the adult world, both past and present. For example, the child modelling clay has become identified with thousands of years of history. The wealth of ceramic forms that remain reveal much about the makers and the age in which they lived. Fine examples of ceramic art, in the hand or seen in the museums, mean much more to the child who has experienced the feel of clay and who has attempted to fashion it.

The provision of fabrics and threads offers another world of opportunity. The direct cutting of shapes (without drawing) is another way of becoming aware of shapes and ideas. The translation of these into collage and embroidery is a means of learning a great deal about embellishment as well as acquiring an increasing range of stitches. Another development is the lead-in to dressmaking through doll-dressing and puppetry. All this work may involve the use of both hand-operated and automatic sewing machines [42].

A piece of wood may have to be shaped with tools before it responds to human intentions. Abrasive tools have their own characteristic effect as they wear down the surface in different directions.

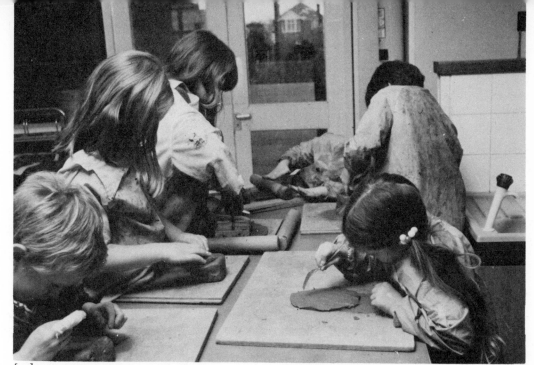

[41]

[42]

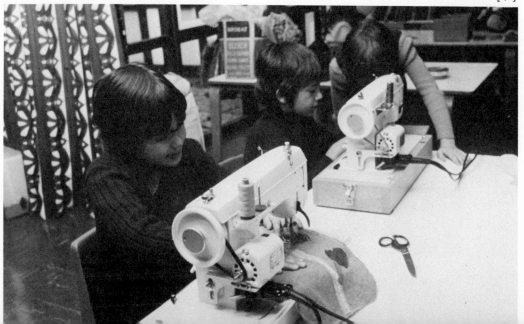

In contrast, a staple of fleece, opened up in the hands [48], is delicate to touch. The would-be spinner is dealing with a material as sensitive as our finger tips which have to come into direct contact with this flimsy substance.

Materials and resources for a range such as those indicated here exist in some measure in each of the schools described. They enable children to build on earlier experiences of tools and materials to achieve expressive work and prowess in craftsmanship with all the potential for insight, imagination and appreciation that these can give.

The development of skills

Young children have a very keen tactile sense and show extraordinary sensitivity [46, 48] in handling materials. The admiring 6-year-old often watches his older school fellows with a keen eye, ready to imitate them. He may notice the correct way in which an older child has been taught to hold the spindle. He may catch the well-measured rhythm of the sawing motion or notice the careful way the older child is joining his sausage of clay to the animal to make a tail, smoothing it on with a wetted finger. The thorough teacher makes sure that he does.

The idea of teaching skills to pupils has been attended by some doubt, perhaps because teachers feared they were interposing themselves between the

[43]

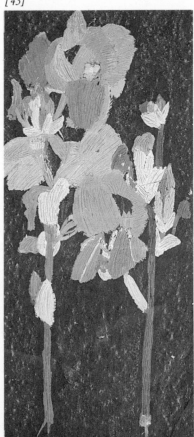

[44]

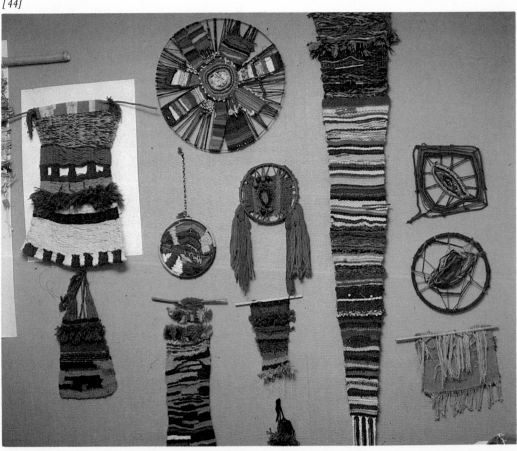

[45]

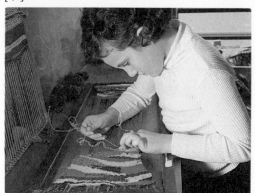

[46]

[47]

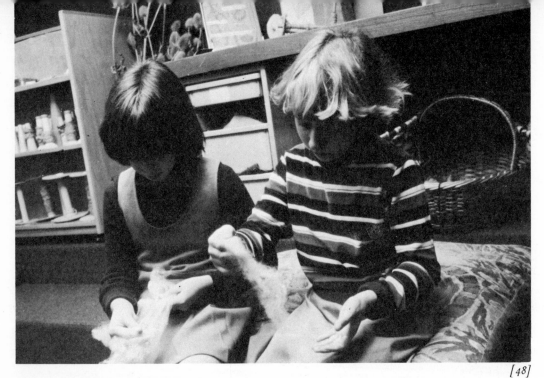

[48]

[49]

achieved if pupils are expected to change too often from one process to another for the sake of superficial variety. Steady practice breeds, in time, the confidence that comes through mastery and empathy with the world of tools and materials. The accounts of the work in Schools One, Four and Seven underline this important point. Assessing the nature and degree of help required depends on the teacher's observation of each child. Some teachers find it helpful and encouraging to keep a collection, of a child's work for a time as a means of assessing progress. Such a collection, with its associated written work, forms the actual record of work in some schools (see School Seven).

Many teachers stress the importance of direct experience but link with this the verbal preparation, the recall of knowledge and ideas and the consideration of appropriate materials. The teacher in School Eight emphasised this. Where pictorial expression is concerned it is possible to help without imposing any narrow view of 'accuracy' on a child's own imagery. Templates, tracings or other formulas are harmful here. The stages of development in children's own pictorial expression are well documented in books on education and easily recognised by the understanding teacher, who will seek ways of furthering the child's progress. For example, the young junior who paints the sky along the top of the paper and ground along the bottom, at the same time developing quite realistic images of houses and friends [47, 49], but who still conforms to the well-known practice of having space between to convey the idea of the air in which we live and move, is showing the logical thinking typical at this stage. One day, suitably timed, his teacher will help him really to see the weather moving along behind the trees and chimney pots. Only then will he honestly fill the gap which naturalistic convention does not recognise. Later he will understand other equally valid but different conventions.

Teachers should be alert to the question of size. Some ideas are better expressed on a small scale but

child and his own vision of the world. But children denied guidance are unduly handicapped in developing a personally expressive style.

Teaching the skills of seeing, selecting and recording honestly and with care are major aims in these nine schools. There is also an emphasis on training children to adopt a disciplined approach to tools and materials so that waste is minimal and nobody comes to a job to find things out of place, or dirty or spoiled. Well planned and orderly classrooms of every type, size and scope were visited, where each type of activity had its space and children understood clearly how to use it. The photographs of classrooms and workspaces illustrate the disciplined approach common in these schools.

The growth of manipulative skill and competence takes time and steady application; it cannot be

it is also true that lack of feeling and knowledge about a subject inevitably produces small and unconfident work – even if this has been chosen by the child. Small pictures on a part of the paper can often be expanded into big ones by accretion as the child is helped to realise how much more he knows or feels about the topic. Sometimes other children will join in, attracted by the enlivening conversation that the teacher has instigated to help the first diffident effort. Seeing needs to be developed by all possible means suitable to the interests, age and stage of the children. The teacher may be interested in visual appearances from various points of view, all encouraging sharper perceptions. He may be looking as a scientist, an engineer or a gardener – or as a painter, an archeologist or a geologist. He brings his own interests into focus as he talks with children and challenges them about the shapes, forms, patterns and colours that they see [45]. The descriptions of the teaching in Schools Six, Eight and Nine exemplify this.

Choosing and choice are often mentioned in education. Offering a wide range of subjects, materials or opportunities does not necessarily mean that a child has a real choice or can get any value from the choosing; he may merely suffer from bewilderment. Practice in selecting and rejecting is vitally necessary, so skilful teachers plan and limit the range and extent of what is offered in order to make the choice possible for the inexperienced pupil. They know that children need help in fitting the material to the job. For example, a child making a study of spiders may need to draw on a small scale, with a fine tool. Wax crayon on glazed paper would hardly be suitable here. To make a surface texture, it is neither appropriate, nor economical, to use expensive translucent tissue, screwed up.

Craft skills are often acquired through emulation of teacher or peer [8, 23]. We saw examples of both. Some things such as the sophisticated process of screen printing, must, initially, be demonstrated by the teacher. Once learned, it opens the door to a wide field of reprographic experiment which other children share through helping those who received that initial lesson. Important skills can be fostered by

[50]

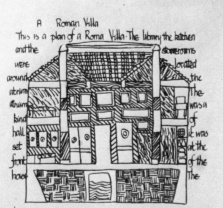

[51]

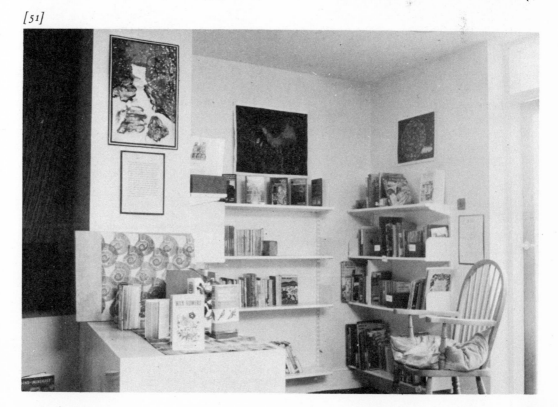

encouraging experiment in certain specific ways [52]; by questions about the nature of the original experience and the choice of the right materials for the job.

The making of books [53] and the presentation of work [50] (including writing) is a feature in several schools where the skill of handwriting is also well developed. Rhythmic movement and touch are especially important in learning to write. Good handwriting and clear presentation on the page aid thinking. Good layout also helps the reader to absorb the contents. Where handwriting is well taught in the school this kind of development can be expected at the junior stage.

Pupils are often offered indirect experiences in the

[52]

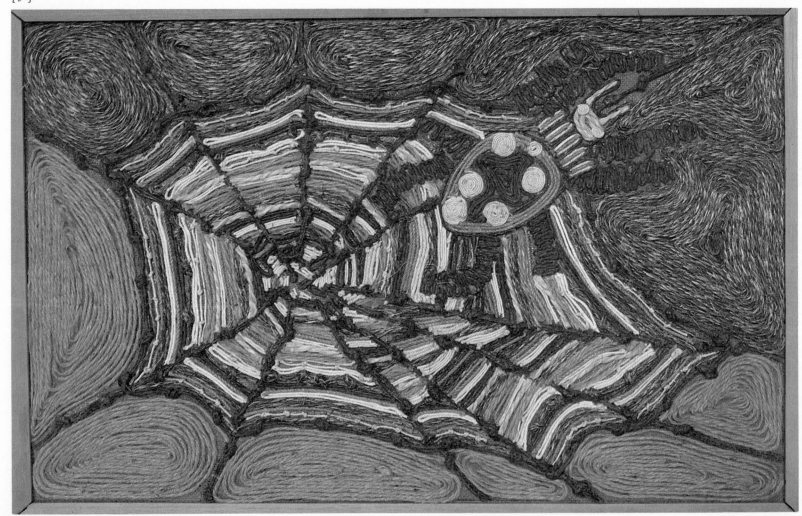

form of films, good visual illustrations and books. Teachers need to ensure that these are the best quality they can find since such experiences can be very significant in establishing an interest in and appreciation of art. We have seen in some of these schools that children can make successful use of reproductions or photographs, selecting for themselves what they believe to be significant and using it much as they do printed information when they read, and reproduce in their own words. A child's work in art may involve a sensitive selection from a variety of direct and indirect experiences – some of these are visual, others may be intellectual, or emotional – which are then assembled by the child in an unique synthesis as a picture or model or piece of craftwork. All children need to take part in this process of recreation if they are to enter fully into everything that education can offer at this stage.

The examples described and illustrated show how far children in this age range can be taken, honestly and naturally, if they are taught to develop their powers of observation, their sensitivity and the language, both visual and verbal, which springs from direct experience and to use their findings imaginatively and personally in creative work.

The percipience and skill with which they select and record the subject matter of their investigations can put them in close touch with their geographical and historical environment. They are using their critical faculties in exacting work, involving an expanding range of craft techniques which, though they may be considered as art, are also contributing to their knowledge in mathematics, science and the use of language. The thought and feeling involved in the manipulation of some of the real materials of the adult world can provide the basis for an understanding of design. Their own creative and imaginative expression arising from their sensitivity to colour and form can foster the growth of an understanding of their cultural heritage in art and architecture.

Some discussion points for schools

1. Is there an effective policy for ensuring consistency of good environmental standards throughout the school? Are there sources of informative and inspirational material of quality for all reasonable purposes? Are these used?

2. Is there a policy for development and progress for each child according to his capabilities? Are there plans for the development of content and of skills in the use and understanding of colour, shape, texture, pattern, form? Is there a programme for the development of appreciation of pictures, objects and buildings?

3. Have pupils and teachers high expectations and standards of achievement in visual knowledge, memory and interpretation?

4. Is there adequate time to learn to observe; in the classroom or in the local or more distant environments; through interest and compulsion arising from many areas of the curriculum in which an awareness of form, order, pattern, design and colour is essential; and for which training and practice are necessary?

5. Is there an awareness of the special relationship with language development? With science and mathematics? With humanities and environmental studies?

6. Does any teacher act as a consultant in art? How does he/she operate? If there is no consultant, might the work benefit if a member of staff were so appointed?

7. How are skills taught? What progress is expected? How are stages recorded and assessed?

8. How are materials, tools, chosen, ordered, organised, maintained?

9. What in-service activities are required to promote further skill and understanding? Are there suitable sources of teachers' reference material within reach? Do the teachers know them? Do they use them?

Background reading

Art and visual perception Arnheim, R., Faber 1967.

The loom of art Bazin, G., Thames & Hudson 1962.

The necessity of art Fischer, E., Penguin 1970.

Art and illusion (4th edition). Gombrich, E. H., Phaidon Press 1972.

The nature of creative activity (2nd edition). Lowenfeld, V., Routledge and Kegan Paul 1952.

Creative and mental growth (6th edition). Lowenfeld, V., Collier-Macmillan 1975.

The pupils' thinking (2nd edition). Peel, E. A., Oldbourne 1967.

Creative crafts in education Robertson, S., Routledge and Kegan Paul 1952.

Education through art (3rd edition). Read, H., Faber 1958.

The meaning of art (4th edition). Read, H., Faber 1969.

Art and the child Richardson, M., University of London Press 1948.

Draw they must: history of the teaching and examination of art Carline, R., E. Arnold 1968.

Change of art education Field, D., Routledge and Kegan Paul 1970.

The intelligence of feeling Witkin, R., Heinemann Educational 1974.

Art and education Steveni, M., Batsford 1968.

Ways of seeing Berger, John, BBC/Penguin 1972.

Children solve problems de Bono, E., Allan Lane 1972.

1000 years of drawing Bertram, A., Studio Vista 1966.

Safety at school: general advice DES Safety Series No. 6, HMSO 1977.

Safety in practical departments DES Safety Series No. 3, HMSO 1973.

Printed in England for Her Majesty's Stationery Office
by Tonbridge Printers Ltd, Tonbridge, Kent
Designed by HMSO/John Hughes
Dd 595894 K80 5/78